How to Draw
Fairies

In Simple Steps

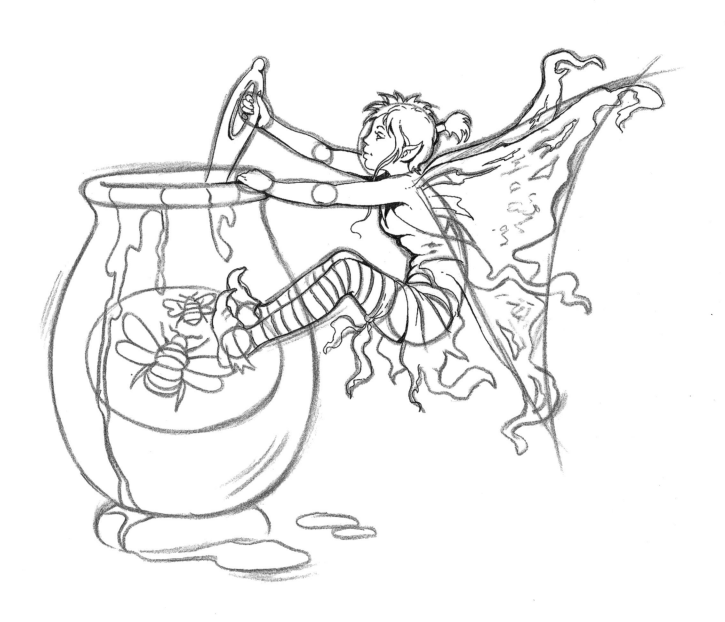

First published in Great Britain 2009

Search Press Limited
Wellwood, North Farm Road,
Tunbridge Wells, Kent TN2 3DR

Reprinted 2010

ISBN: 978-1-84448-371-6

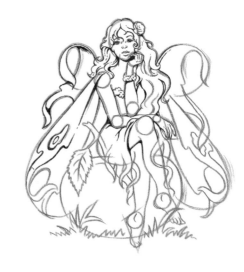

Dedication

For Julie – Fairy Queen

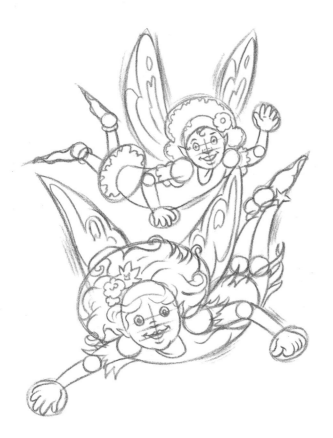

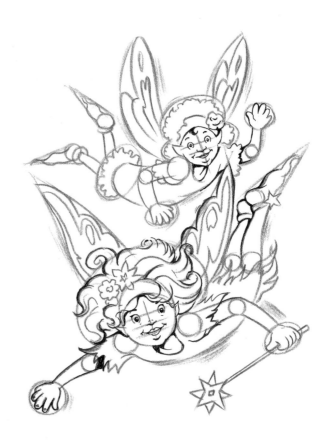

Printed in Malaysia

How to Draw
Fairies
In Simple Steps
Paul Bryn Davies

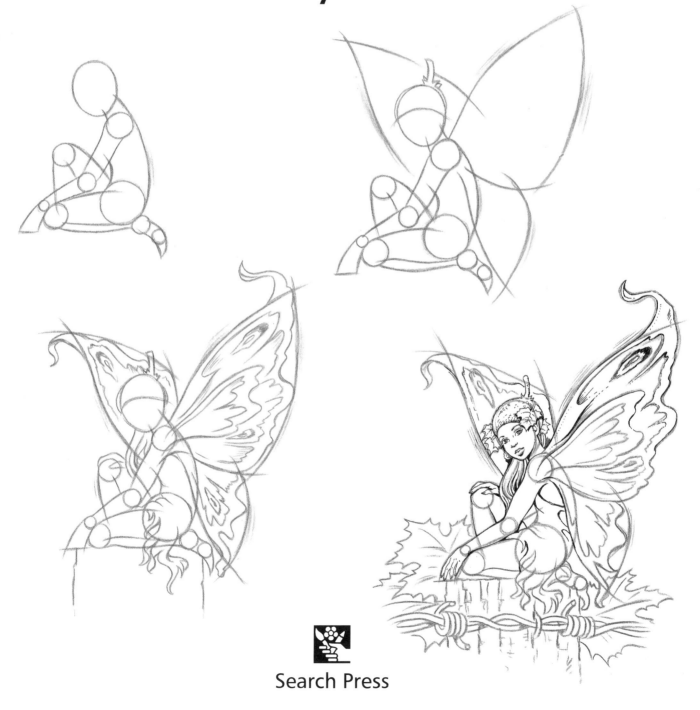

Search Press

Introduction

Welcome to Fairyland. In the following pages, I use simple step-by-step drawings to show how to create the most magical of all fantasy creatures – the fairy. I have included a varied collection from cartoon-style winged folk to more realistic fairies; some mischievous, others beguiling, but all of them beautiful. The cartoons will appeal to children of all ages and any artist who is young at heart. The realistic drawings may appear more sophisticated, but the methods of building up the images are exactly the same and if you follow the stages you will soon master the simple construction techniques.

The aim of this book is to demystify the drawing process and to encourage aspiring artists to view a fairy as a collection of simple shapes. When an image is broken down into interlinking circles, ovals and triangles in this way, the process becomes much easier. Two colours are used in the stages, to make the sequences easier to follow, starting with burnt sienna. I continue to use this colour in subsequent stages, but change to violet when adding new lines or shapes. This method is used only to highlight the difference between one step and the next; there is no need for you to do the same. Start by gently sketching each stage using a fairly soft pencil: HB, B or 2B, then erase any unwanted marks after each one is finished. When the final image is complete, ink the drawing in with a technical pen, a fine ballpoint pen or a fine-tipped felt pen. Make sure all the pencil lines are erased when you have finished.

I have used watercolours applied with an airbrush for the final images and added gouache highlights. This offers inspirational colour ideas, but there are no rules in Fairyland. You could use acrylics and different colours, or experiment with pencil crayons and colour markers. Alternatively, if you have the equipment and skills, scan your drawings into a computer and colour the images digitally.

If you believe in the legends about these elusive creatures you will know that they are impossible to find, so I have taken my inspiration from nature, as well as rural and urban environments. Fairies closely resemble us and understanding the basics of human anatomy will help if you want to progress and draw your own folk. Simplify the head and body shapes, as shown in this book, or use tracing paper if you find it easier. An artist's mannequin is a good source of reference and it can be manipulated into different positions, which is useful. Alternatively, seek photographic references for the basic figure. Family and friends may be able to help you with this. A final note about wings: these important features can be as simple or as exotic as you like. Look for reference by studying butterflies, lacewings and similar flying insects. If you use this book and follow my advice, you will soon start to feel more confident about your drawing skills and you will develop a style all of your own.

Happy drawing!

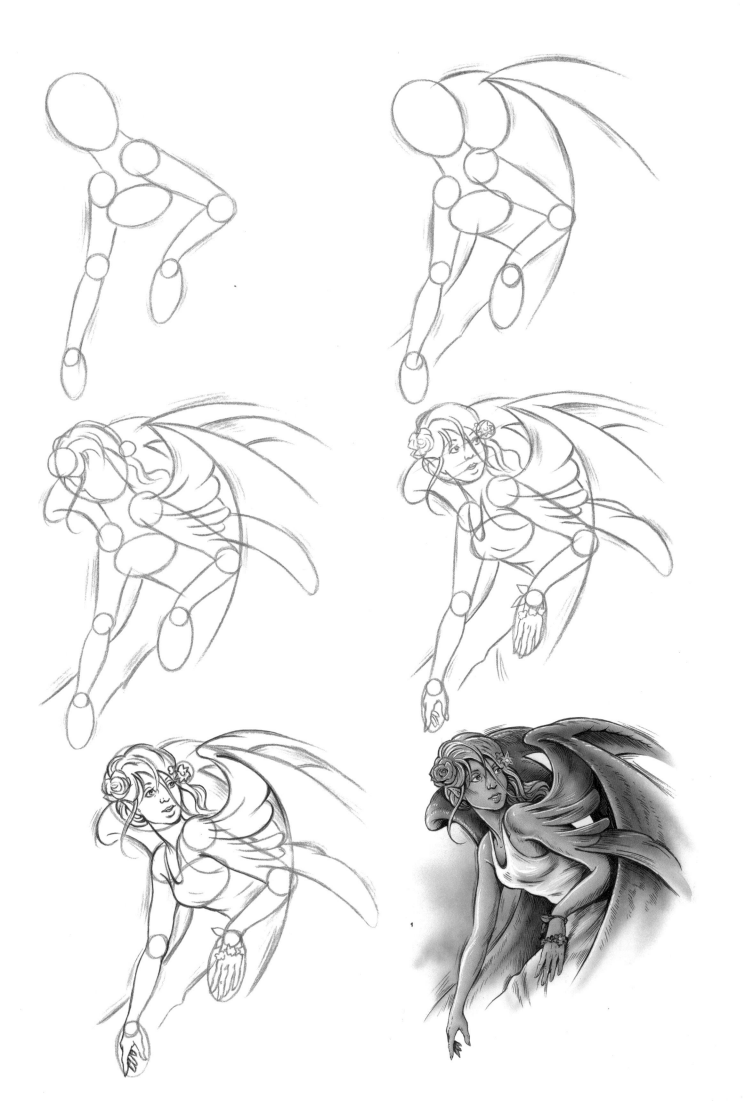

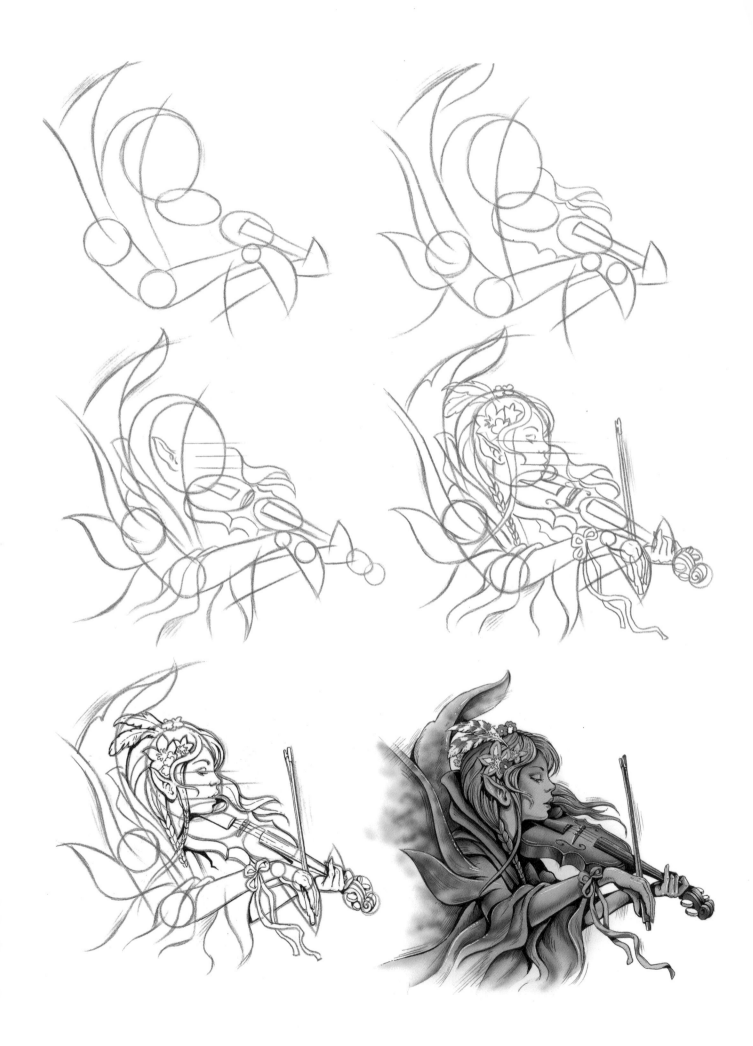

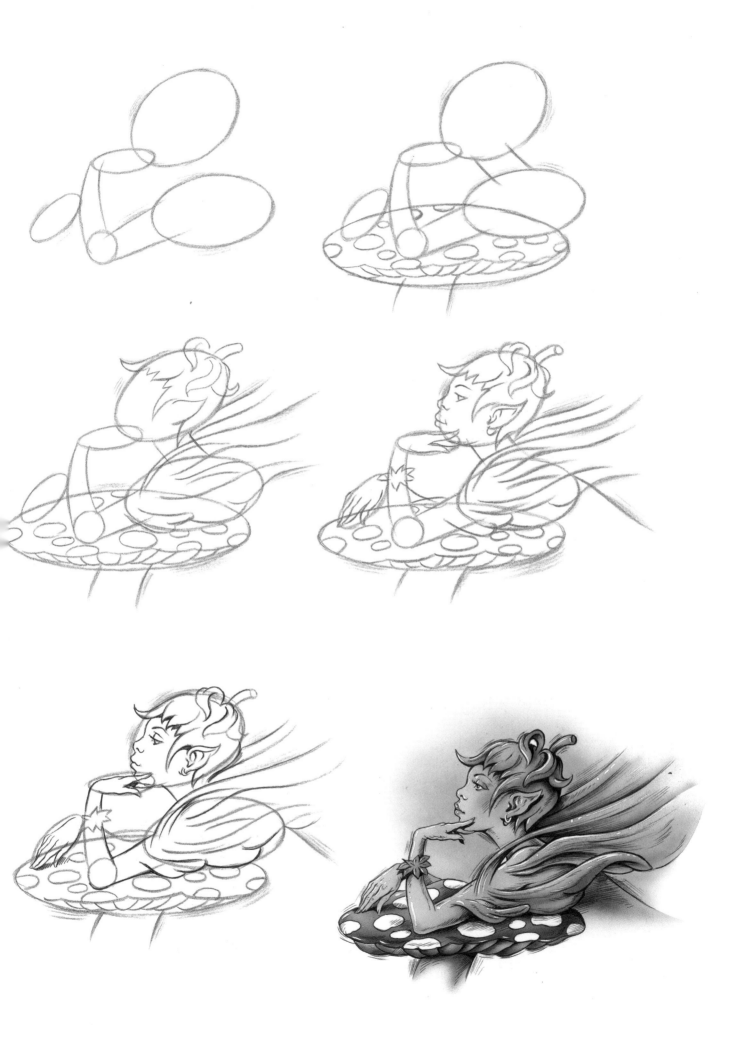

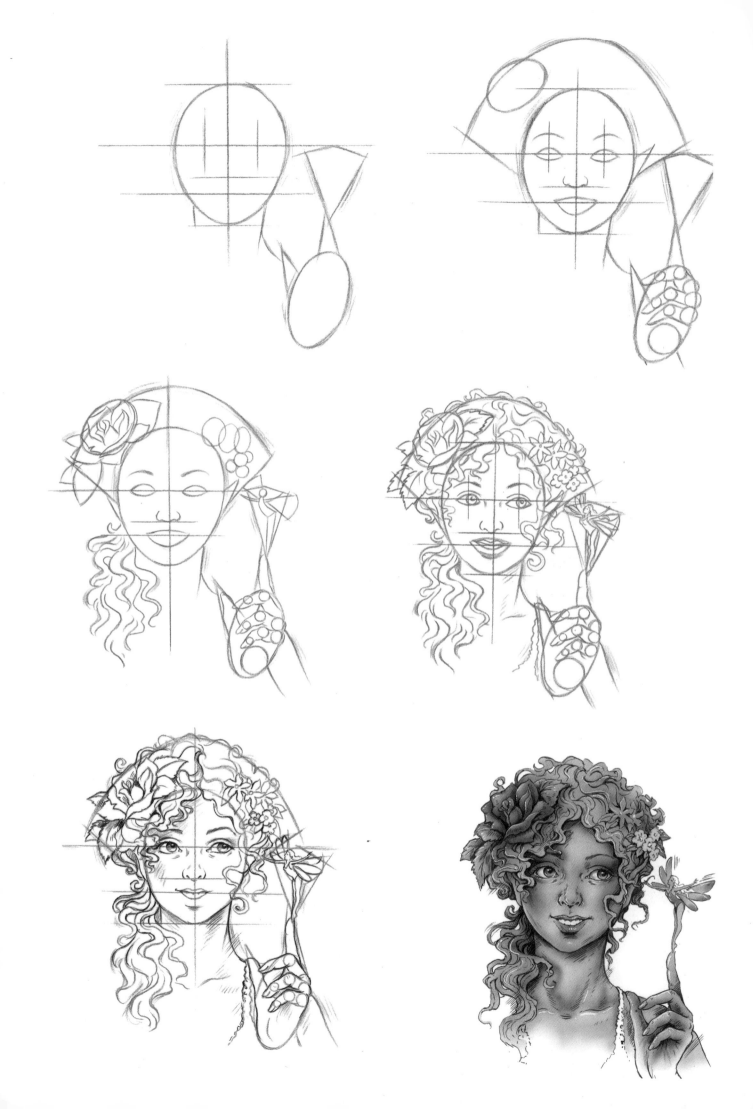

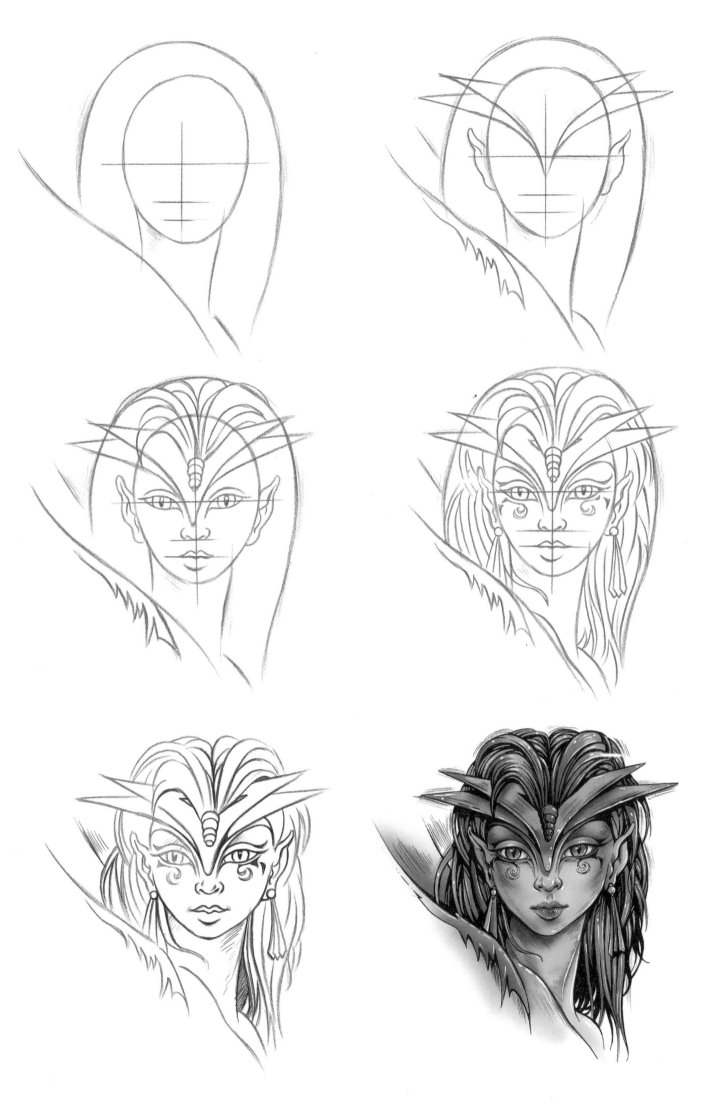

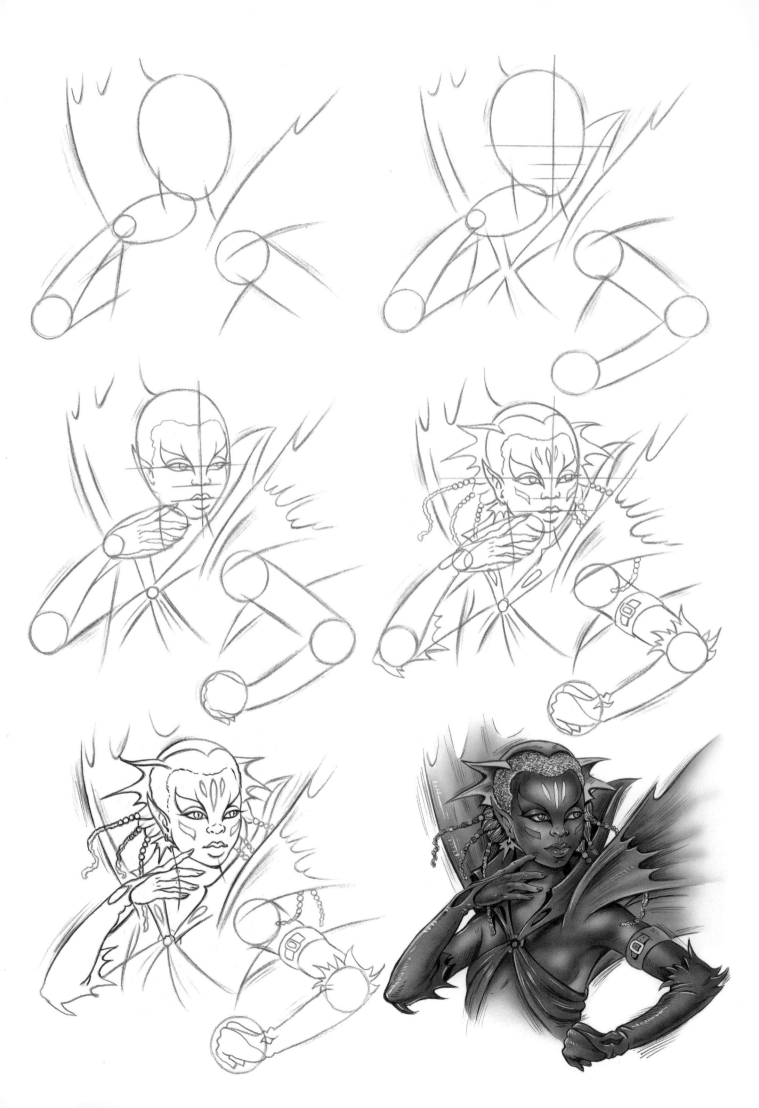

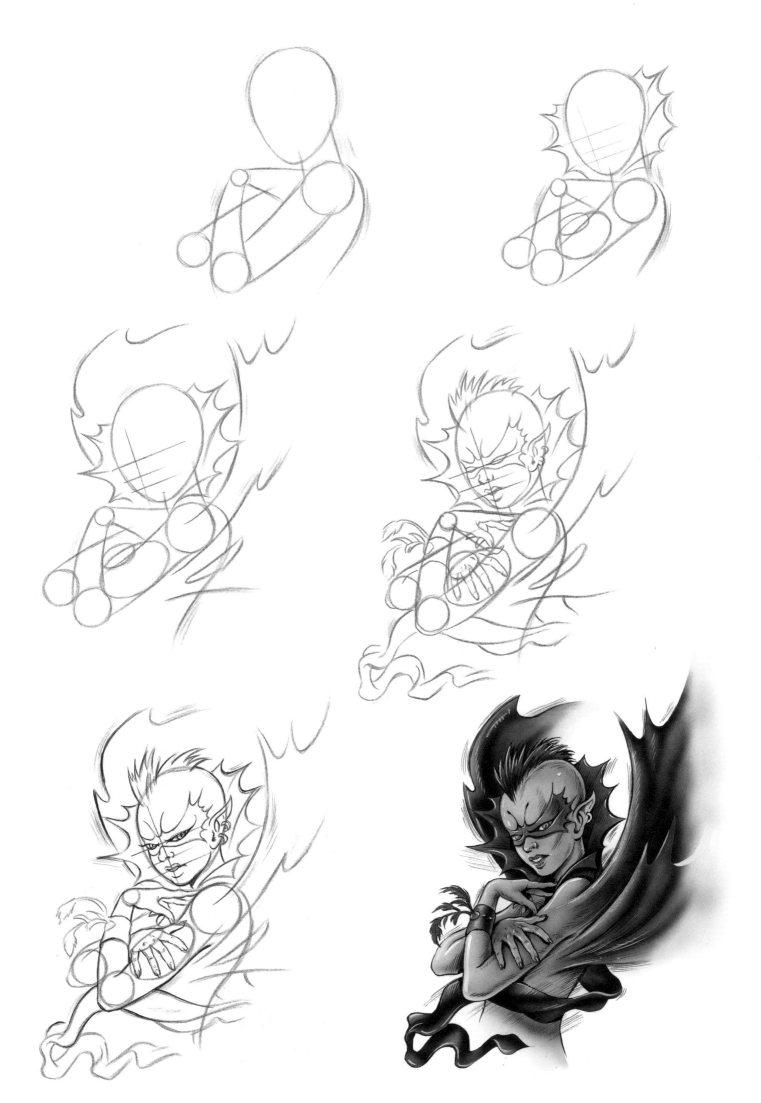

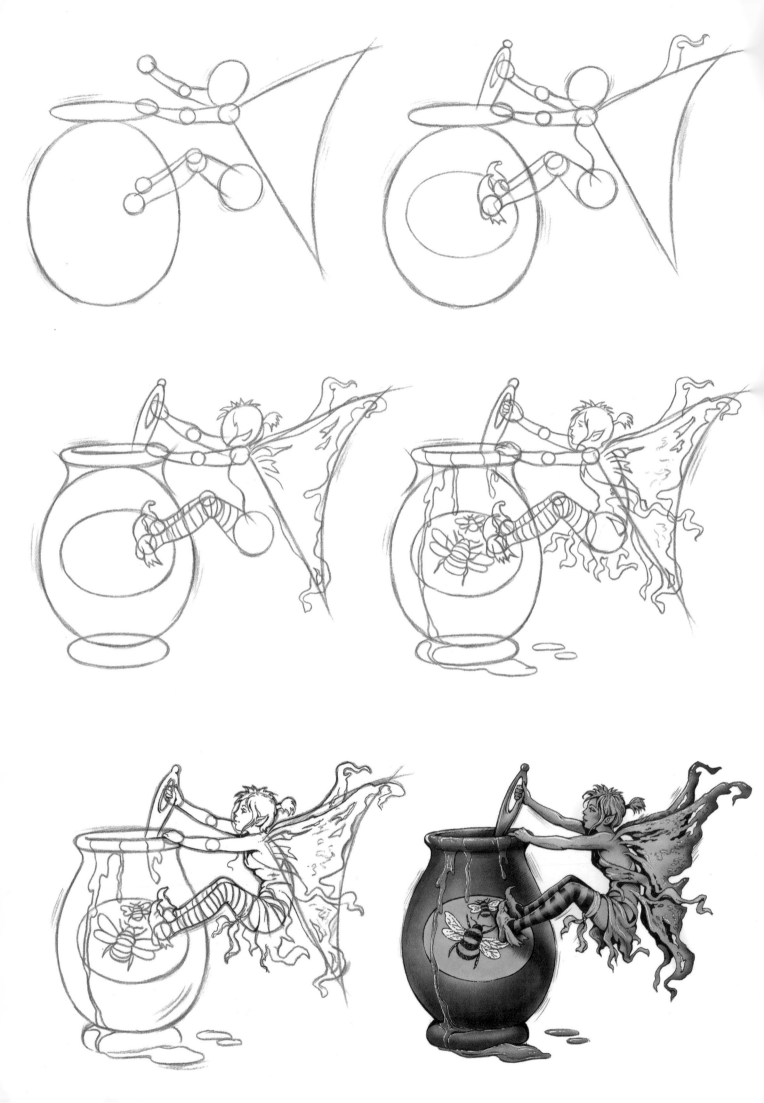

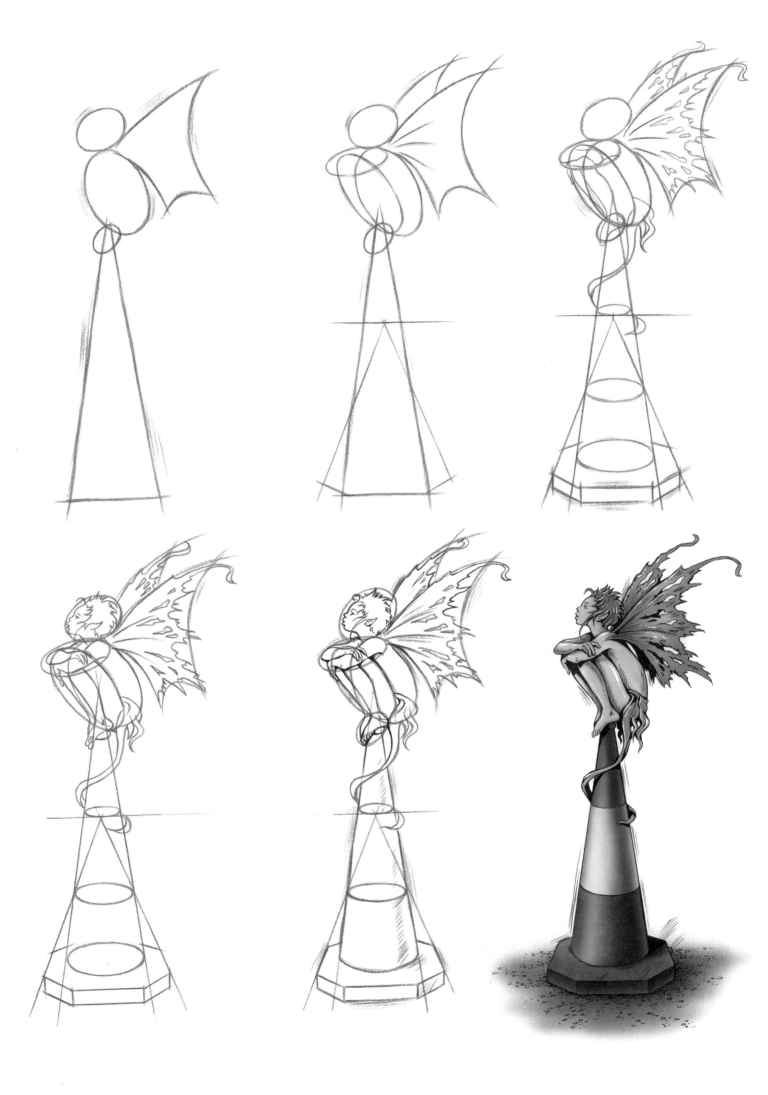

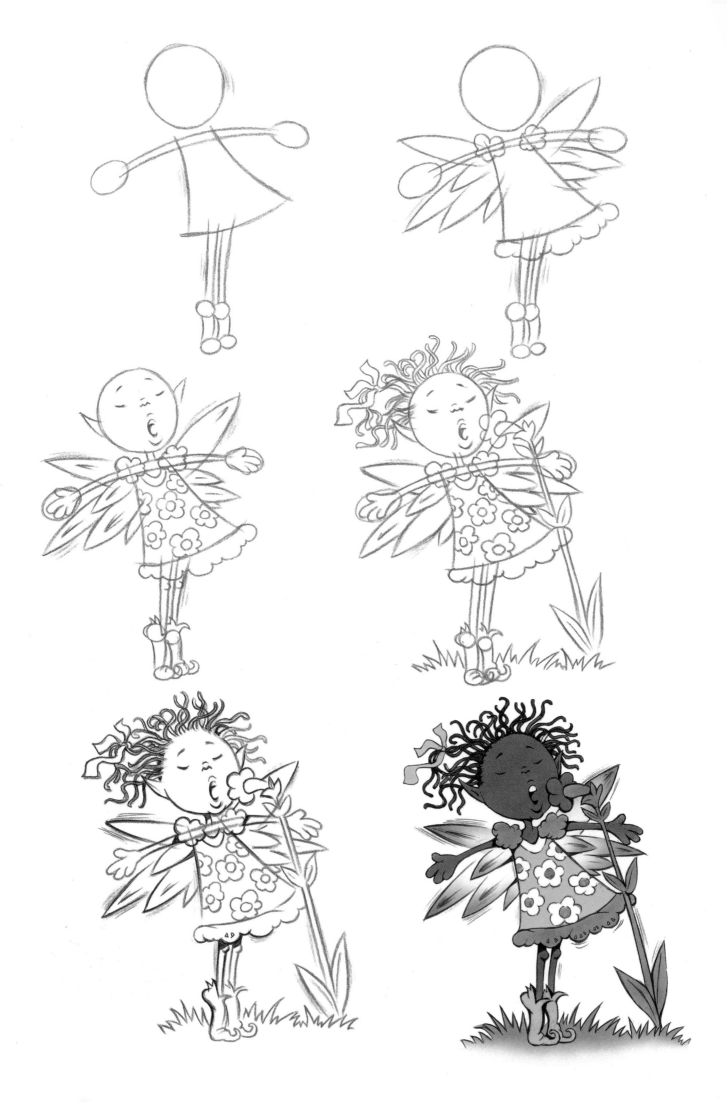

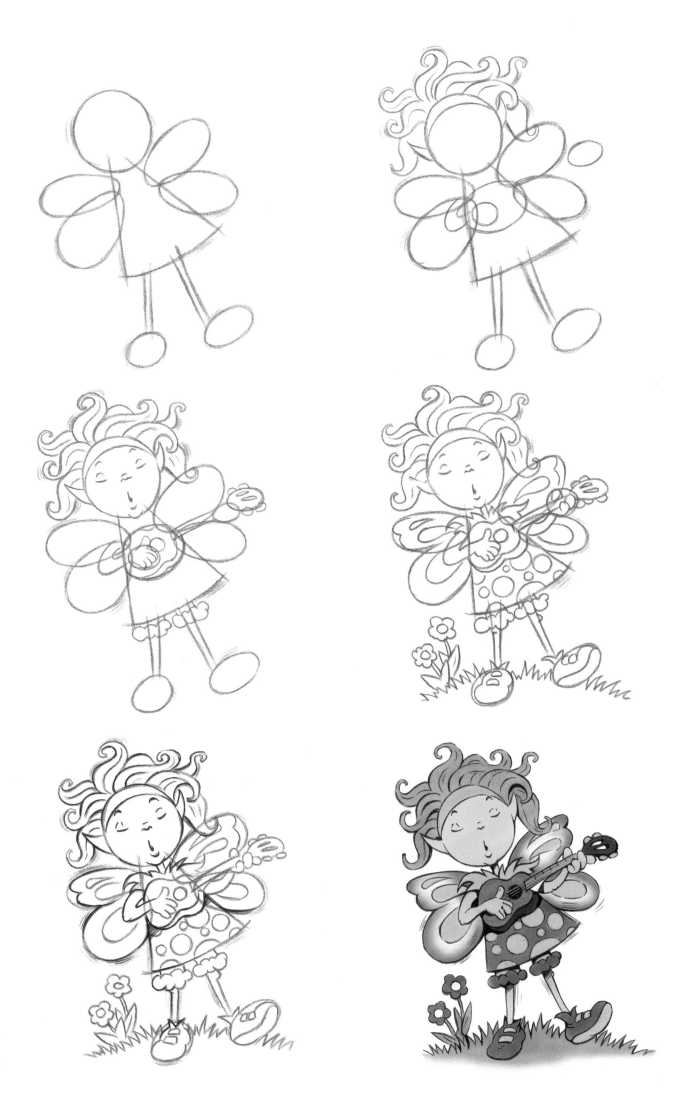

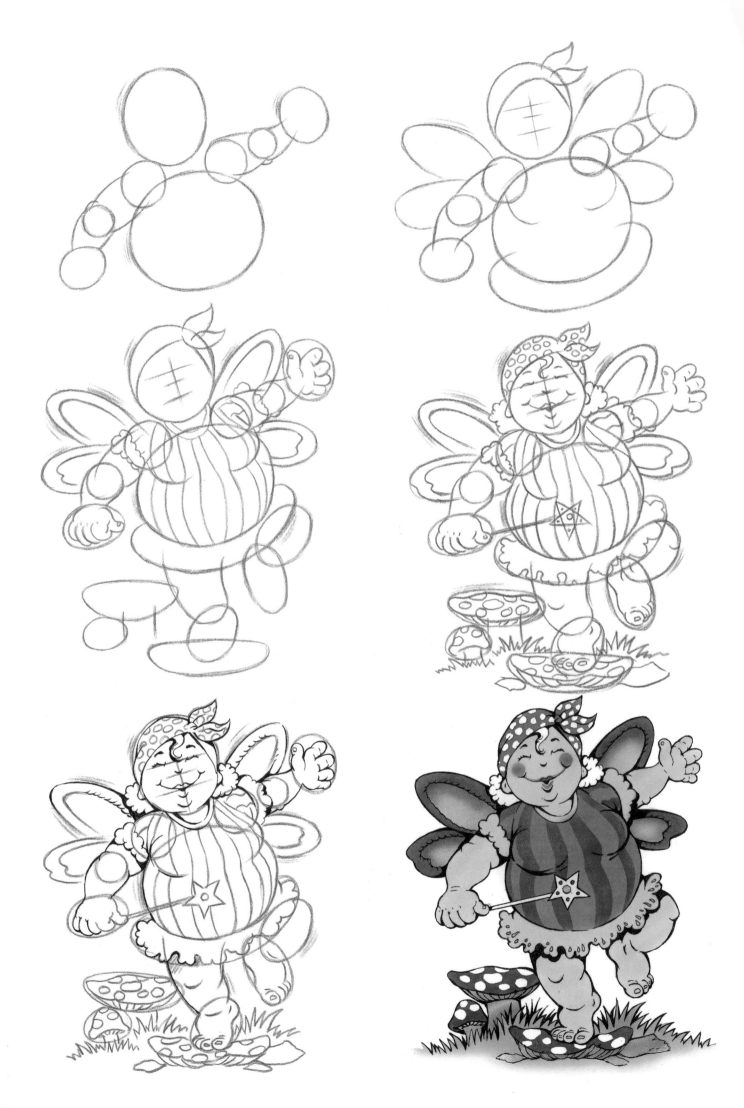

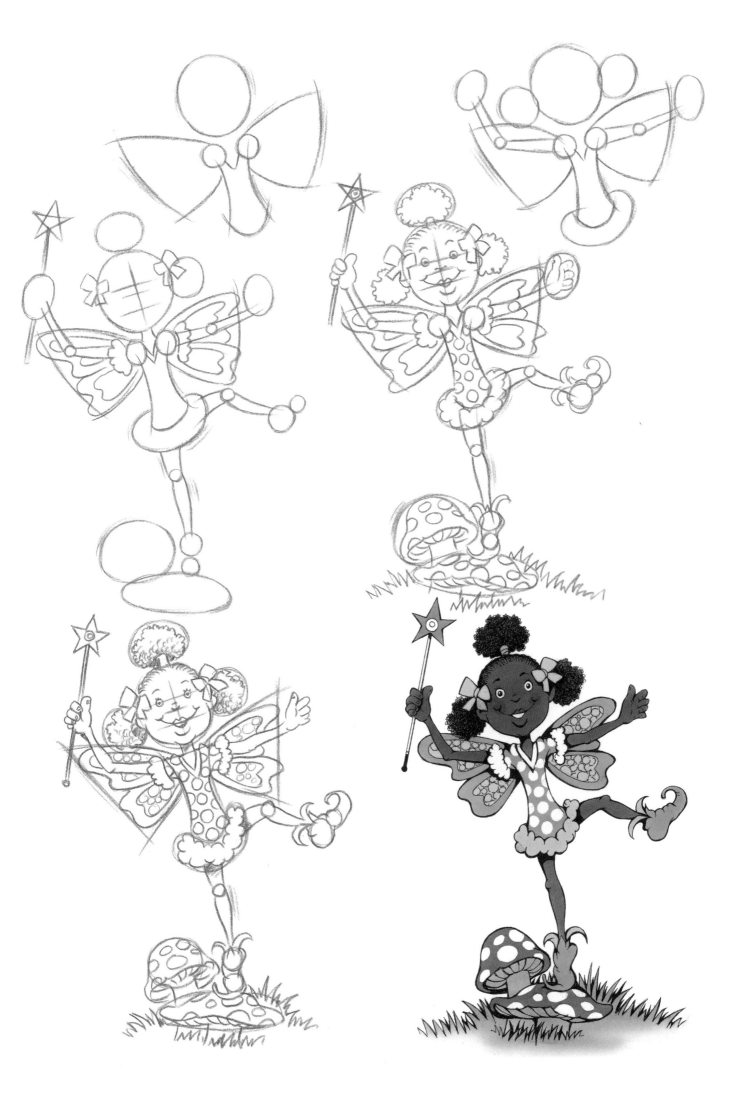

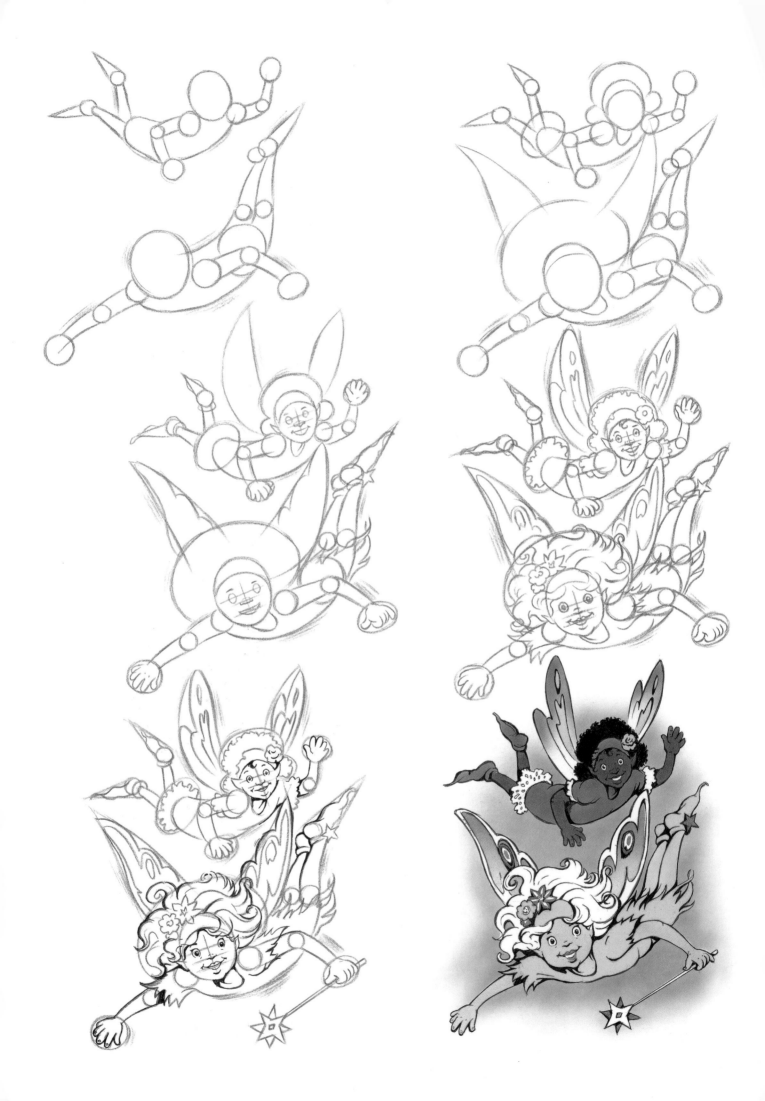

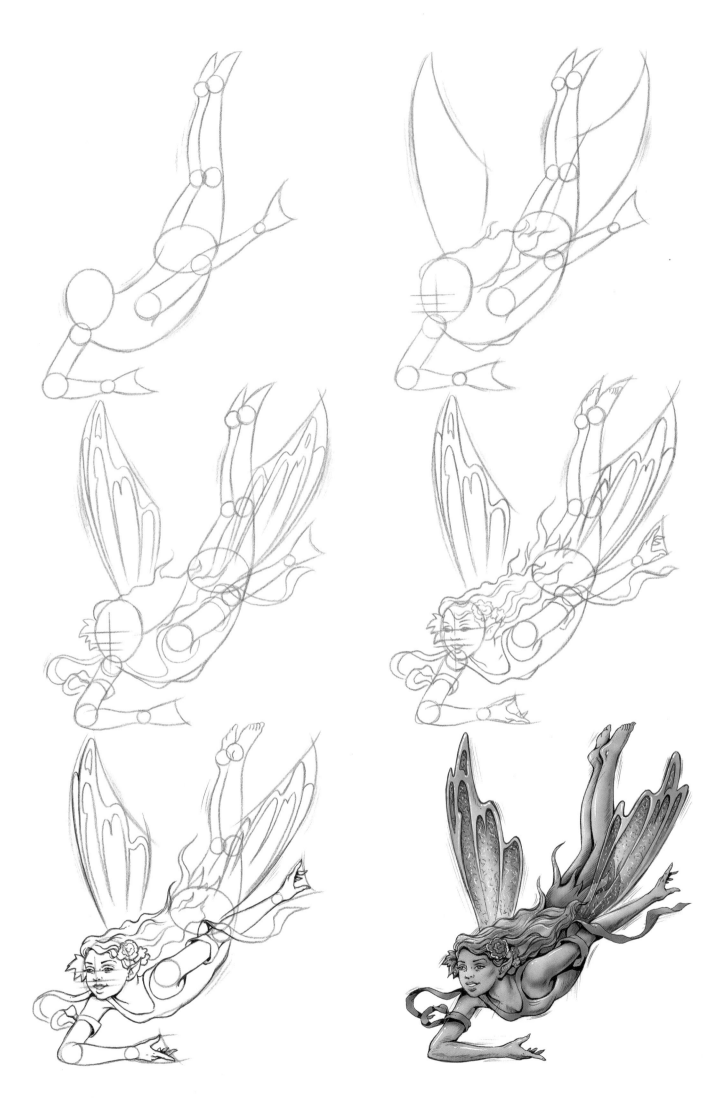

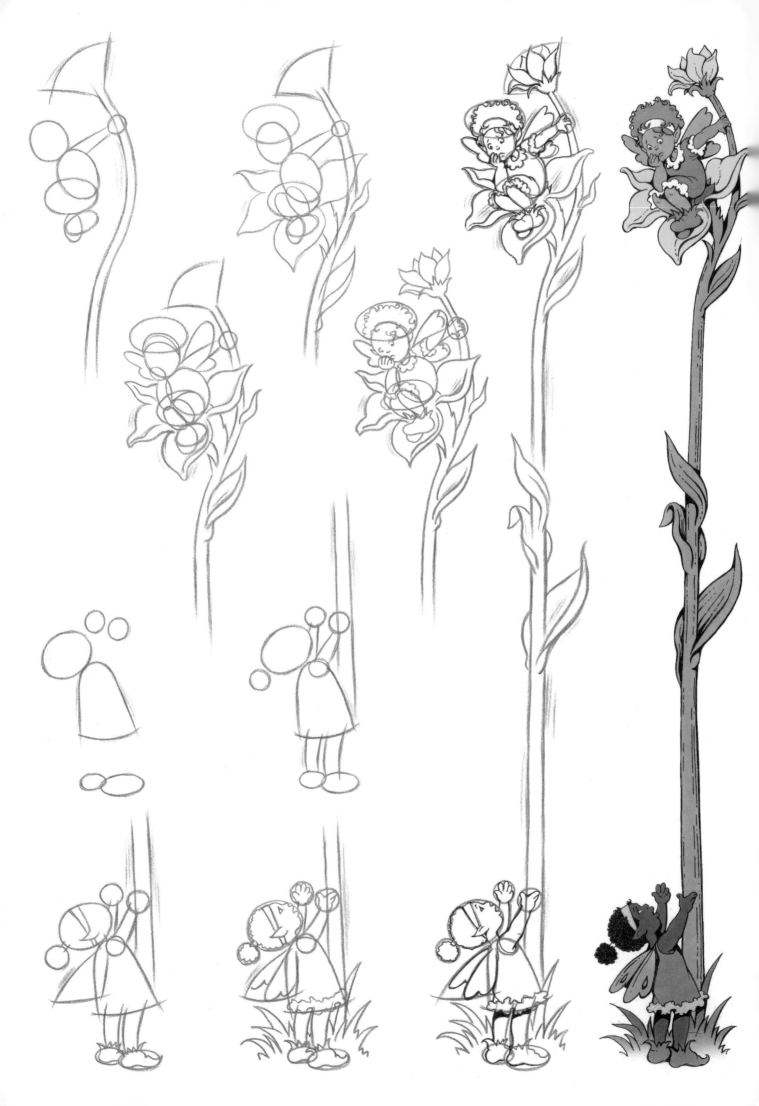

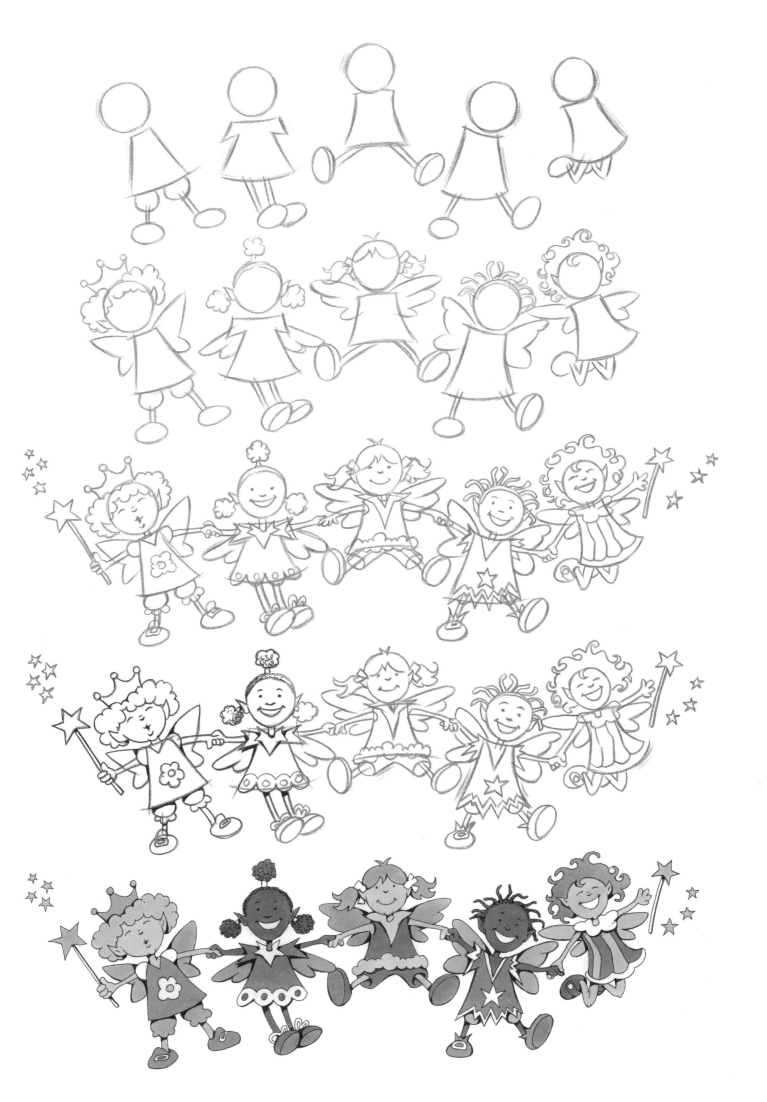

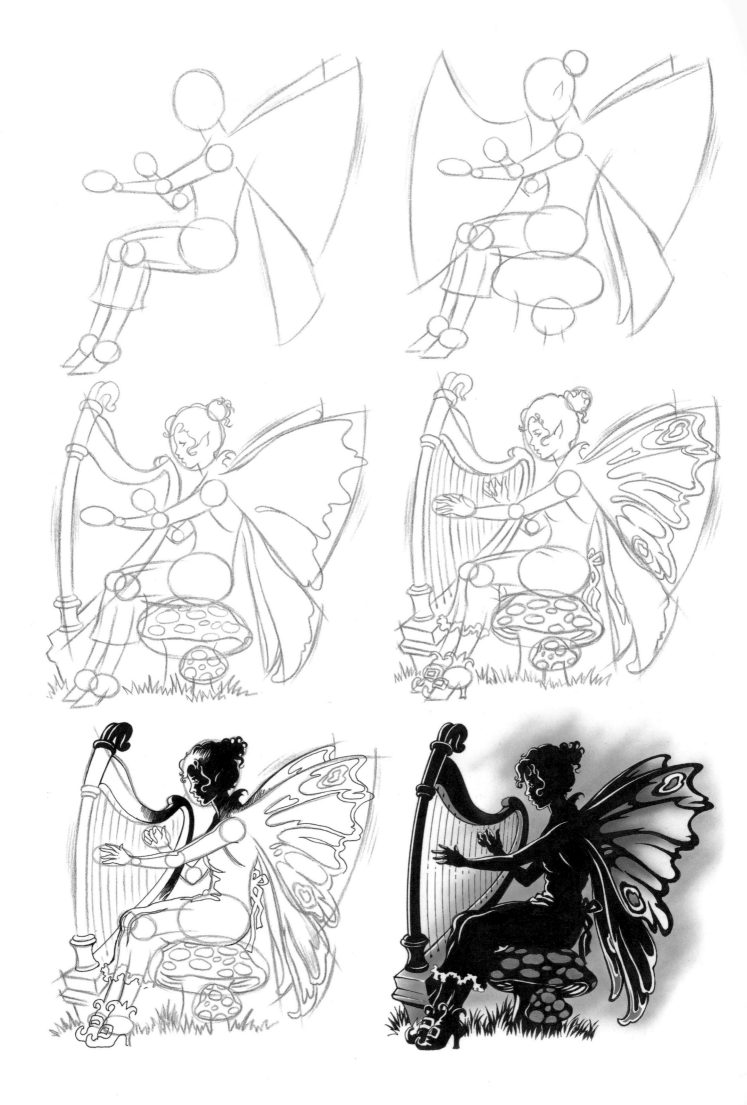

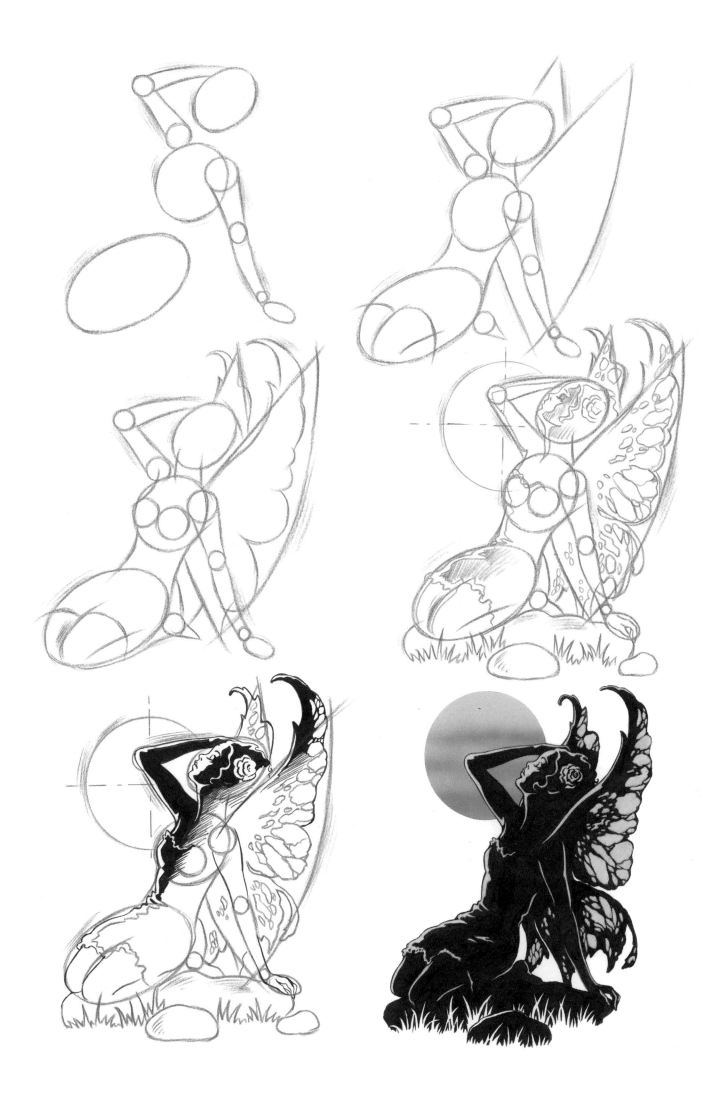

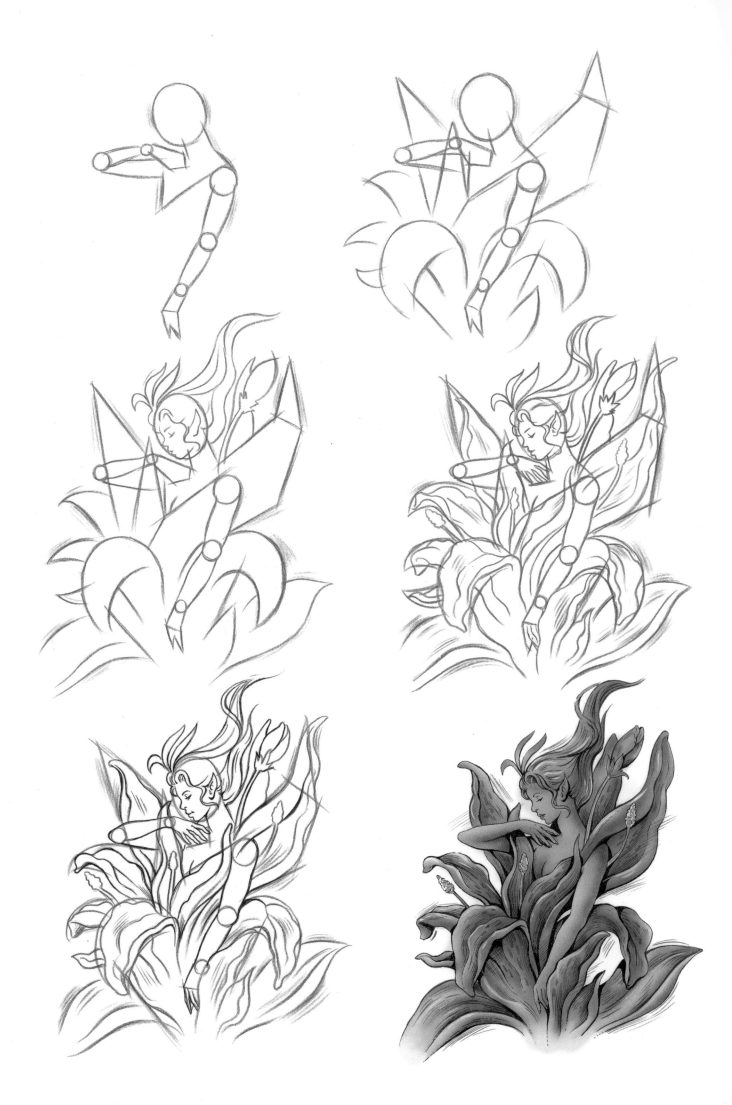

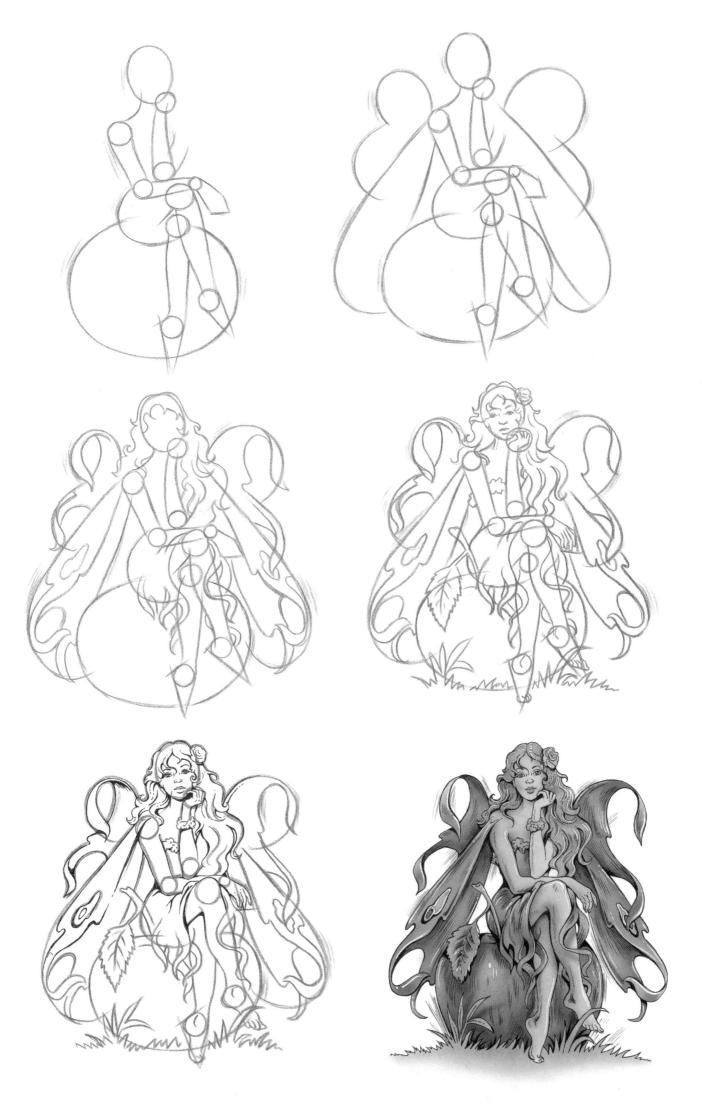

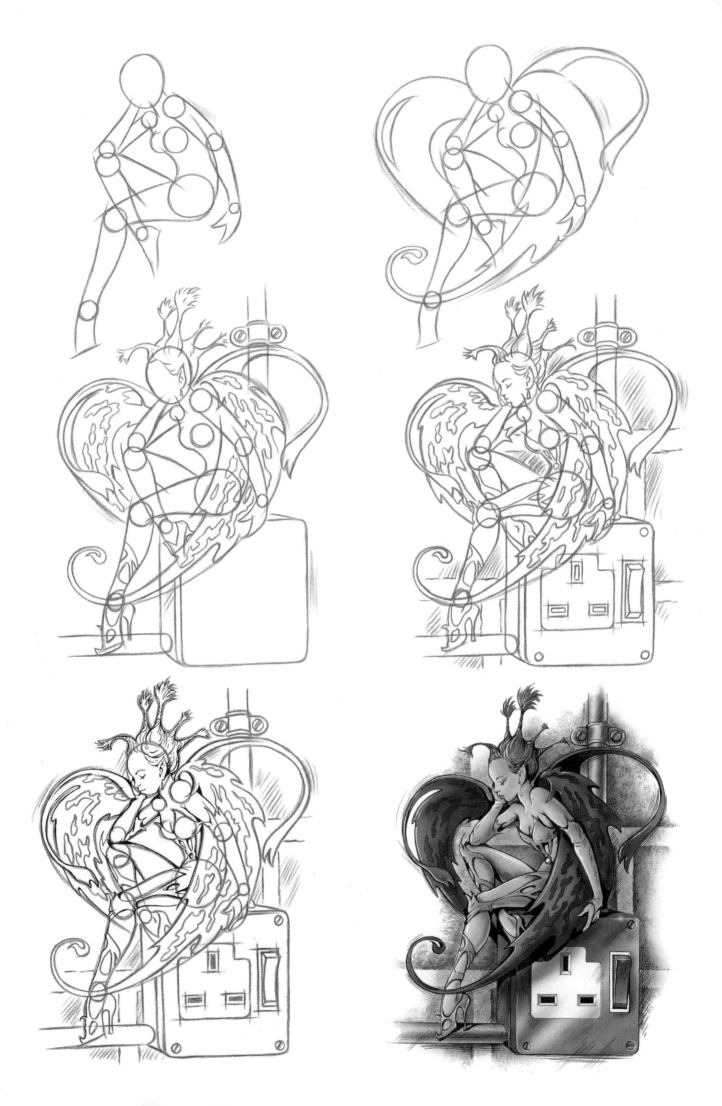

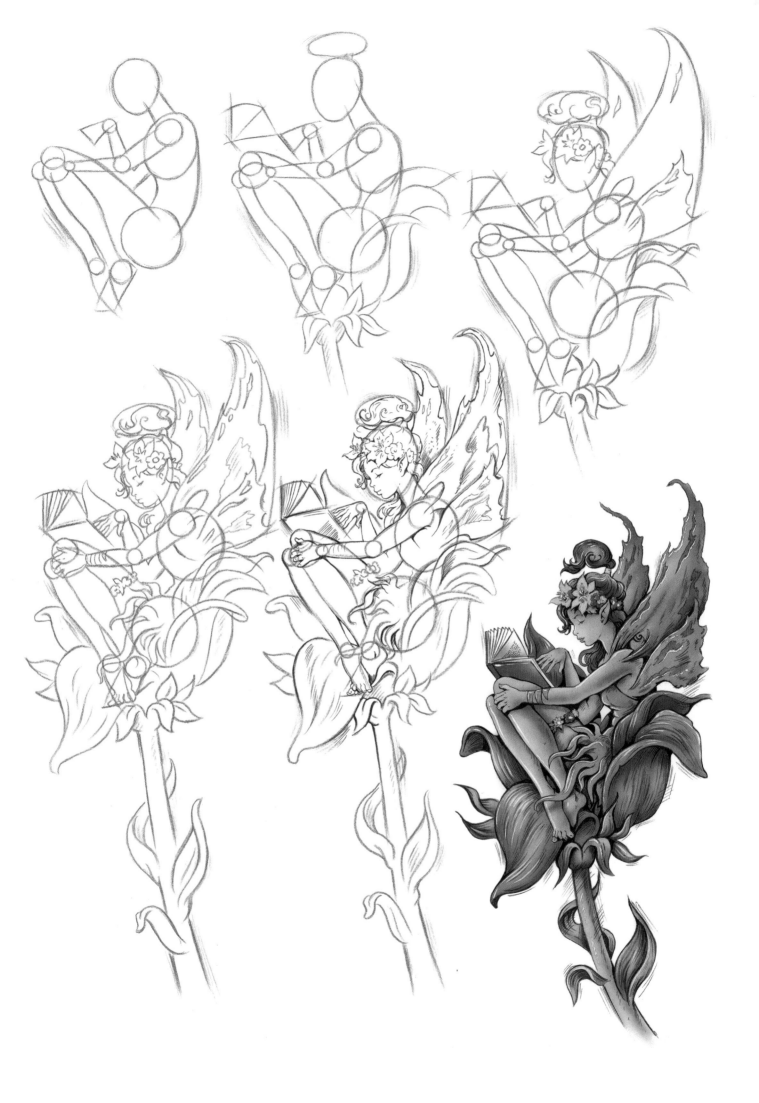

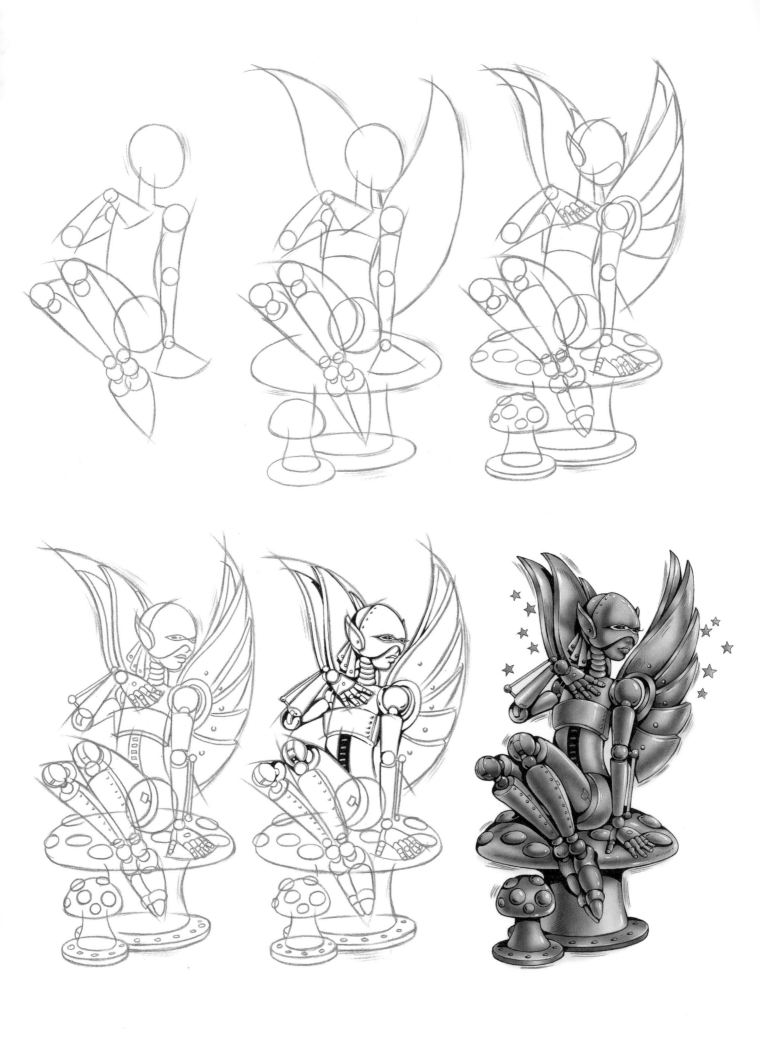

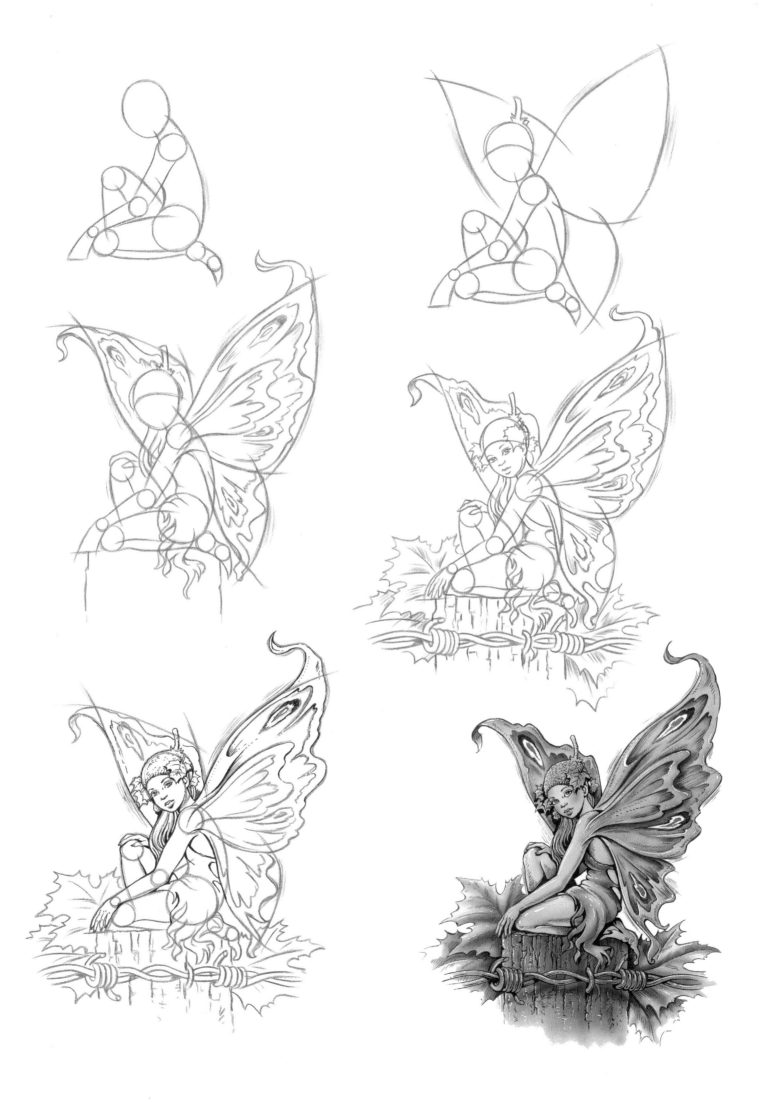

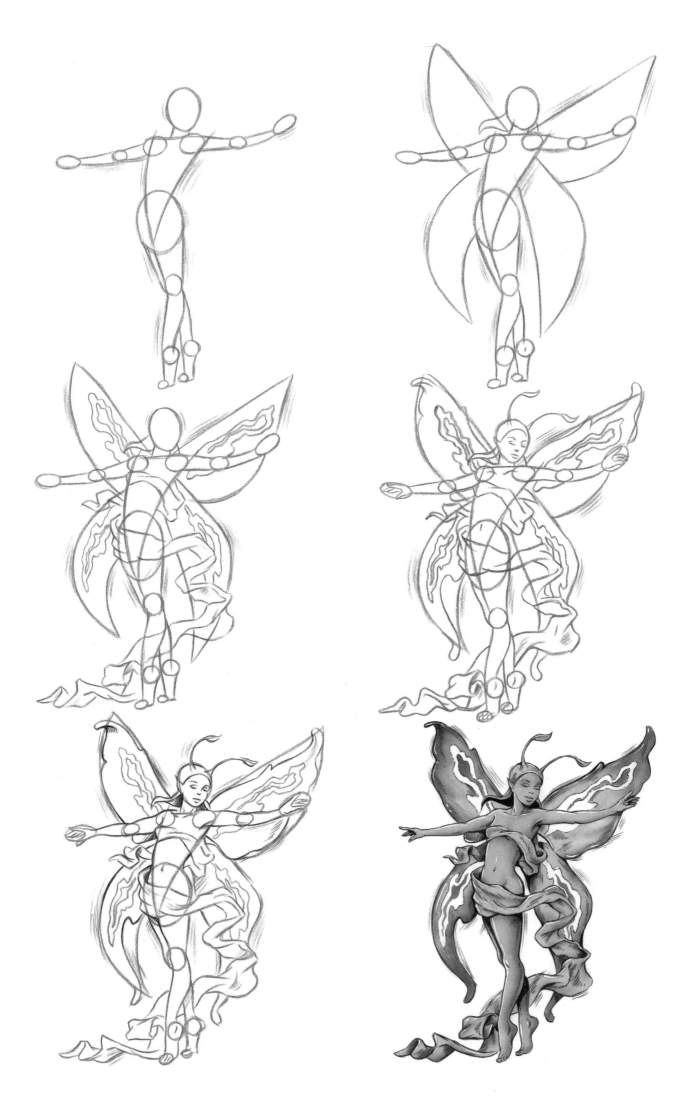

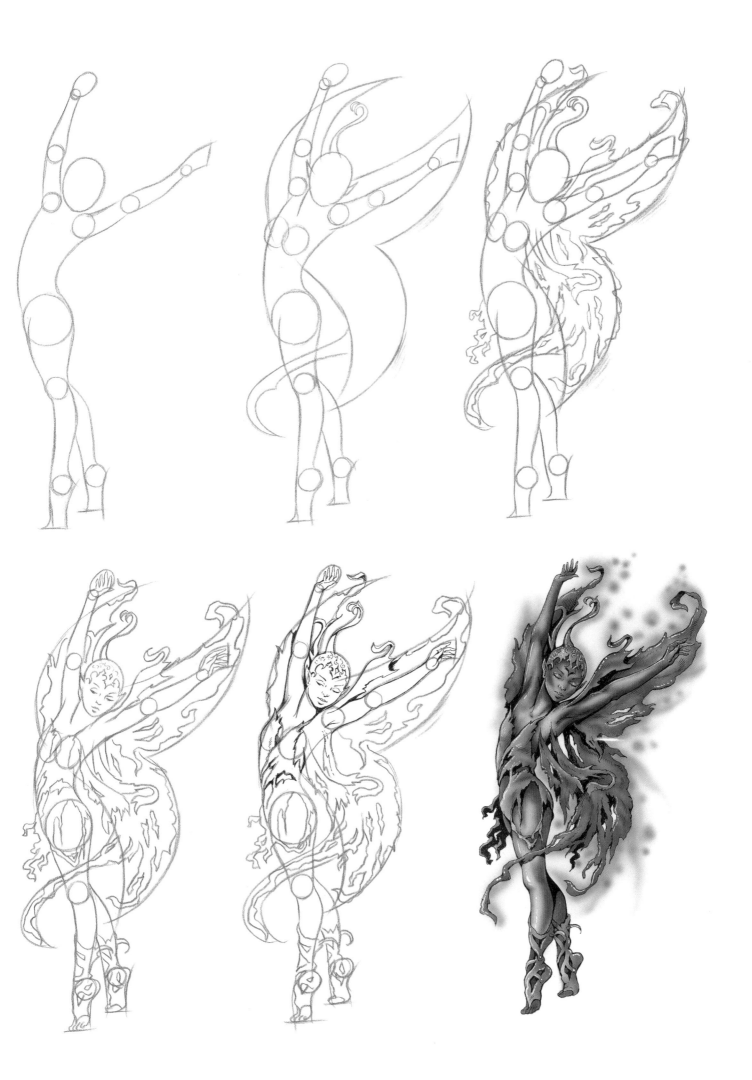

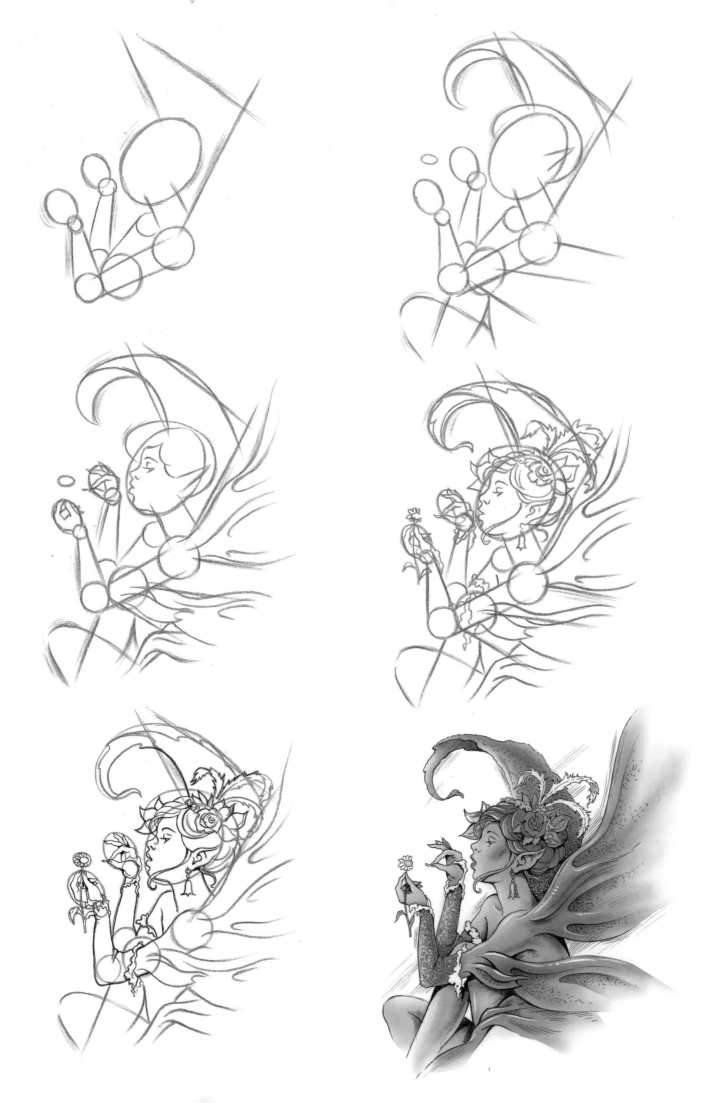